THE APERTURE HISTORY OF PHOTOGRAPHY SERIES

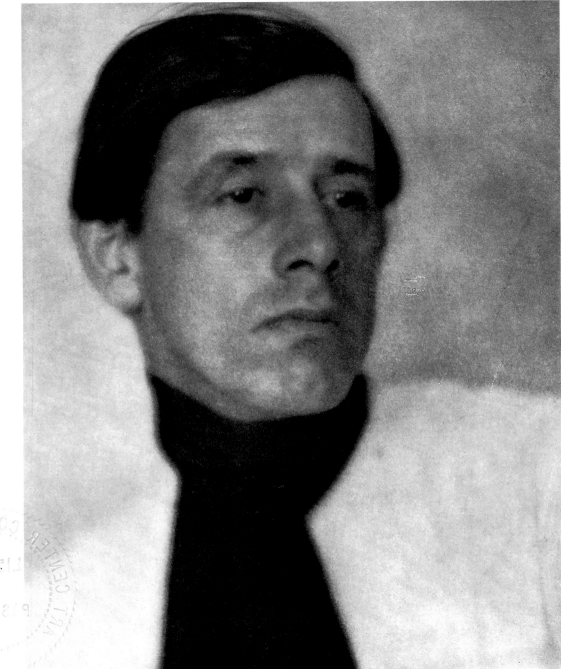

Clarence H. White

APERTURE

The History of Photography Series is produced by
Aperture, Inc. *Clarence H. White* is the eleventh
book in the Series.

Aperture, Inc., publishes a periodical, portfolios and
books to communicate with serious photographers and
creative people everywhere. A complete catalogue will
be mailed upon request. Address: Elm Street, Millerton,
New York 12546.

Library of Congress Catalogue Card No. 77-80019

ISBN 0-89381-019-3

· Manufactured in the United States of America.

In his eleventh-hour autobiography of 1966, the pioneering photographer Alvin Langdon Coburn spoke of the life and work of Clarence H. White: "I think that if I were asked to name the most subtle and refined master photography has produced, that I would name him. . . . To be a true artist in photography one must also be an artist in life, and Clarence H. White was such an artist."[1]

Many may disagree with Coburn's implied judgment that White is one of photography's preeminent figures. Few, however, will disagree with Coburn's description of White's photographs. They are both "subtle" and "refined," and are unquestionably the work of an artist. Those who knew White would also concur that he was "an artist in life"—in the depth of his own feelings, in his warm family relationships, in the closeness of his friendships. And many of his students have declared that it was a warmth, even a luminousness, in his character, rather than anything specific he taught about cameras or film, that inspired them through the process of self-discovery to become artists themselves.

Despite the fact that he was a masterly photographer, and a unique and successful teacher for the last eighteen years of his life, White said very little about the art of photography. As director of the Museum of Modern Art's Department of Photography, John Szarkowski has said, "During his long fruitful career it seems that he made not one memorable statement concerning his sources, his intentions, or his methods. Surrounded by theorists, prophets, and publicists, White remained merely an artist."[2] There are several reasons for this. One was diffidence: the painter Max Weber, who knew White intimately, once remarked that White was "a very modest man, but an artist, truly."[3] Another was undoubtedly White's perception that photography was in danger of being overwhelmed by an avalanche of words. Early proponents of photography as an art were so busy defending photography, insisting upon its legitimacy as an artistic medium, that at times they nearly obscured it with verbal overkill. To White, photography was a very personal and individual matter. Its essence was simply the discovery and development of one's own vision.

This should not suggest that White was a loner. He knew most of the photographers of his time, often very closely, and realized even earlier than his co-workers that collective effort was necessary if photography was to gain equal status

with the other visual arts. As early as 1899, three years before Alfred Stieglitz's landmark "Photo-Secession" exhibition in New York, he held an exhibition of major contemporary photographers in Newark, Ohio, his hometown. In fact, White devoted his life to a quiet but unceasing effort to further the aims of photography from the time he took his first experimental pictures in 1893 until his too early death in 1925.

Clarence Hudson White was born in the small Ohio town of West Carlisle on April 8, 1871, early in the era christened by Mark Twain as the "Gilded Age." But throughout his life White marched to the beat of a different drummer—his eyes, like Thoreau's before him, focused on the true gold to be found in nature and its truths. In a time dominated by the gospel of wealth and the Horatio Alger myth, White was a gentle historical anachronism. His first sixteen years were spent in the small village of his birth, and there he gained a deep and abiding sense of place and family, as well as an intimate feeling for the whole fabric of nature with its changing cadences and harmonies. To White it was the job of the photographer to capture the subtle moods and rhythms of the natural world. In a rare published interview given late in life, he stated:

> He [the photographer] should go out into the fields with an open eye and open mind to be moved to an expression of his appreciation of pattern, his appreciation of tone, of values, etc. Let him leave the mind open and that will tell him what to express. He gets his inspiration from nature and he contributes to nature just so much as he has knowledge of photography, knowledge of composition, knowledge of tone values—he expresses himself that way. I do not believe he should go with a preconceived idea of what he is going to get. He should be moved by his subject. If he is not, he will become blind to the most beautiful aspects of nature. That is the interesting thing of nature; the changing light and shadow are never twice the same. The light is continually changing, and he has combinations and variations that a man with a preconceived idea will miss, and in photography that is the most important thing—that it can record these subleties.[4]

White grew up surrounded by a large collection of aunts, uncles, and cousins in the family-owned American House, a tavern his great-grandfather Augustine White had built on arriving in Ohio from Fauquier County, Virginia, in 1817. Hard-working Presbyterians, the Whites were known for their lively sense of humor that belied their sometimes harsh, rural Calvinist faith. The family had been early settlers in America, and Clarence White's Virginia ancestors had fought in the French and Indian War and the Revolution. One of his favorite uncles, hard-drinking, boisterous Uncle Gus, had somehow survived three years of the bloodiest fighting of the Civil War from Shiloh to the Battle of Stone's River to Chicamaugua to the victories of Lookout Mountain and Missionary Ridge.

The cultural influences were not all of a military nature. White's maternal uncle, Ira Billman, was a published poet, and in 1904, using his sons Lewis and Maynard as subjects, White provided photographic illustrations for a volume of his uncle's verse, *Songs of All Seasons,* that consciously or not re-created visually his own boyhood and that of his brother Pressly. The one surviving account of White as a boy, left many years later by an old school chum, describes him as serious but fun-loving, studious but interested in art, especially the violin.

Possessing neither canal nor railroad, those prerequisites for economic success in nineteenth-century Ohio, West Carlisle experienced a steady population decline in the 1880's. White's father, Perry, sold the American House, his grocery and his other properties, and in 1887 moved his family to nearby Newark, Ohio, where he took a job as a traveling salesman for the wholesale grocery firm of Fleek & Neal. Here Clarence White finished his formal education, graduating from high school in 1890. He then took a job as bookkeeper for the firm where his father worked.

Three diaries, covering in part the years from 1890 to the eve of White's marriage in 1893, show White's omnivorous appetite both for athletics and for intellectual and artistic pursuits, especially a new-found ability to draw. Soon he was producing a torrent of pictures done in pencil, crayon, pen-and-ink, and watercolor. Many are still extant and constitute a graphic account of his genesis as an artist.

One of the subjects of these drawings—and, as indicated by the diaries, a frequent date whom White took to concerts in Newark, at nearby Dennison University in Granville, and in Columbus—was Jane Felix, an attractive blonde two years White's senior. A schoolteacher, she was the daughter of Welsh-born John Felix, who had made a small fortune selling supplies to the goldminers of California during Gold Rush days. White and Jane Felix were married on June 14, 1893, at the odd hour of 6 A.M., and immediately boarded a train bound for Chicago to attend the World's Columbian Exposition. It was their first real contact with the work of the major artists of the day. Jane White remained her husband's artistic partner for the rest of his life, serving as catalyst, critic, business manager, model and buffer against the intrusions of the outside world.

White's photographic production from the time of his marriage until 1906, when the Whites moved to New York, was the richest of his career—a remarkable fact, given the circumstances in which he worked. White was totally self-taught, having never had a day's worth of training in photography as an art or in its chemistry. His salary as a bookkeeper was so modest that when the Whites' first son, Lewis Felix, was born, he and Jane were still living in his parents' house. And he had little free time. He reported for work at 7 A.M. six days a week and left at 6 in the evening. Even Sundays were not always free.

"By dawn and evening," reported a recent article on his beginnings, "he posed·his relatives and

friends in what his contemporaries considered 'horrible' lighting. . . . According to Miss Laura Beggs, director of the Newark Historical Society, there are still [in 1972] people living in Newark who remember rising at 4 A.M. to pose for White."[5] This sometimes meant a predawn trip by family or friends on bicycles, on horseback, or in a buggy to some field or orchard or to the bluffs overlooking the Licking River. White himself once commented on the reaction to his lighting:

> The photographers always asked the question, 'What lens do you use'—the artists, 'Where did you study composition?' My photographs were less sharp than others and I do not think it was because of the lens so much as the conditions under which the photographs were made—never in the studio, always in the home or in the open, and when out of doors at a time of day rarely selected for photography.[6]

Commenting on White's work, Beaumont Newhall has noted: "What he brought to photography was an extraordinary sense of light. 'The Orchard' is bathed in light. 'The Edge of the Woods' is a tour de force of the absence of light."[7]

As for White's financial limitations, his student Ralph Steiner shared this remembrance with the writer:

> The one thing he said which did leave a mark on me was that in Ohio, when he worked for a wholesale grocer, he had money each week for only two 6½ x 8½ plates. He spent every spare moment planning what he'd do with those two plates on his weekend.[8]

The key was planning. Once White had envisioned the result he wished to achieve, he strove with great discipline to realize his concept. He was fascinated by the effects of white on white and black on black, and without fear he pointed his camera into the sun. The effects were lovely, as can be seen in "The Sisters" (cover)—a grouping of his wife and her sisters attired in white gowns in a room flooded with the light of early morning. Beaumont Newhall has remarked that as a consequence of both his careful planning and his unorthodox methods, "he pushed the photographic medium to its very limits, and developed a style so personal, so individual, that his photographs are never to be confused with the work of others, and were seldom imitated."[9]

Critics and art historians often comment on how artists from remote precincts of the United States must overcome the limitations of such backwaters. White triumphed, as he knew, by *using* his adversities, by turning them to his advantage. Rather than dimming or stultifying his creative stirrings, Newark, Ohio, nurtured them and exhibited pride in his accomplishments. "I was surprised," White said late in his life, "when the photographs pleased others, but they did and drew me into a circle of workers for whose judgment I have always had the highest regard."[10] Various members of the community not only rose in the predawn hours to model for him, but also rehearsed their poses for hours prior to appearing

before his lens. An infrequent model of White's remembered these experiences almost three-quarters of a century later: "I posed for him off and on for about five years. . . . I was not paid for the work, which required hours and hours of time—first with one costume then another."[11]

White's work came to national attention with surprising speed. In 1898 it was shown at the landmark First Philadelphia Photographic Salon, where all his entries were accepted and hung by the mixed photographer-painter jury of selection. The following year, White was asked to serve on that exhibition's first all-photographer jury, along with his new friends and fellow photographers Gertrude Käsebier, Francis Benjamin Johnston and F. Holland Day. Not only did American art photography take off with the Philadelphia show of 1898; White's career was also launched, and the show represented the beginning of many friendships that remained important to him throughout his life.

Community pride in White's accomplishments was unbounded, as evidenced by the local Newark newspaper's euphoric article about his Philadelphia trumph:

> Mr. Clarence H. White of Newark, O., is undoubtedly the most successful amateur photographer in the country, and this is no small distinction in a day when camera experts are as common as Colonels in Kentucky. Mr. White won distinction at the recent International photographic exhibit in Philadelphia, to which amateur camerists sent their work from all over the world. . . . Mr. White is a bookkeeper, but he has a soul which soars far above ledgers and day-books.[12]

White soon did what other aspiring photographers in this country have done: he organized a camera club. In 1898 his Newark Camera Club held an exhibition in the home of Miss Ema Spencer, and the following year the members organized a much larger show accompanied by a catalogue. The latter marked the first time in the United States that a leading photographer brought together the work of all the prominent American pictorialists. Included in the 1900 Newark show was the work of White's new friend and discovery, Edward Steichen of Milwaukee, as well as that of the Frenchman Robert Demachy.

It was perhaps White's sense of family and his gift for friendship that prompted him to bring so many photographers and their work together so often. After meeting the leading amateurs of his day at Philadelphia in 1898, he continually invited them to be his houseguests in Ohio. When Edward and Clara Steichen were married in New York, they immediately entrained for Newark to spend their honeymoon with the Whites. It was this sense, largely inspired by White, of the leading photographers constituting a close-knit family, that resulted in F. Holland Day's epic 1901 New School of American Photography exhibition abroad, Stieglitz's Photo-Secession show of 1902 and many of the group shows that followed—and eventually carried the day for photography.

Artists with established reputations were quick to encourage White. The painter William Merritt Chase was generous with his praise and support. That tireless evangelist of art, the sculptor Lorado Taft, lauded White and the Newark Camera Club in an 1898 article in *Brush and Pencil*. Indeed, by the turn of the century, the Newark Camera Club was known around the world in photographic circles. Journals such as *Camera Craft* were soon referring to the "White School" of photography and hailing White as the leader of the "Western Art Movement." White was a founding member of the Photo-Secession in 1902 and one of the very few, to paraphrase Stieglitz's words, who really knew its true meaning. All of this new activity accelerated White's life in Ohio, where he simultaneously tried to make a living as a bookkeeper and prepare for exhibitions all over the world.

By 1904 White had resolved to quit his job and devote himself entirely to photography. For the next two years he roamed the land, as had early American portrait painters, making photographic portraits as a livelihood. He referred to these trips, made mostly in the Midwest, as his "bread and butter trips." Traveling by train and horse-and-buggy, he would make about 200 exposures and then return home to develop and print them. While on the road, he would often stay with photographer friends such as Eva Lawrence Watson and her professor-poet husband, Martin Schütze, in Chicago. These trips were punctuated by lectures to camera clubs, which he made gratis,

and by an occasional Chatauqua lecture, for which he was paid.

On one of these trips he stopped at Terre Haute, Indiana, where he met the Socialist leader Eugene Debs and his wife, Kate, as well as Debs' campaign manager and biographer, Stephen Marion Reynolds. His friendship with the Reynoldses grew into one of the most important of his life, and he regarded his images of them, particularly the children, as among his best and most poetic. White himself soon became a Socialist, making the natural move for a man with his sensitivity to human suffering even when it did not affect him directly. Interested only in creating beauty, White never felt compelled to use his art as social statement, but his letters to friends often contain anguished references to the indignities humans inflict on their fellow man.

Time away from his young family could not be compensated for even by his fascinating travels, and in 1906 he decided to move his family to New York. This had long been the urging of all his photographer colleagues, and after 1900 his friend Steichen, who had left his Midwestern home, added his voice to the chorus of entreaty. White was understandably hesitant to move. He was making a comfortable living from photography in the Midwest, and New York was already teeming with professional photographers. And it would mean leaving his beloved native Ohio. But friends, the Photo-Secession and adventure all combined to persuade him, and he and Jane resolved to try their luck in the East.

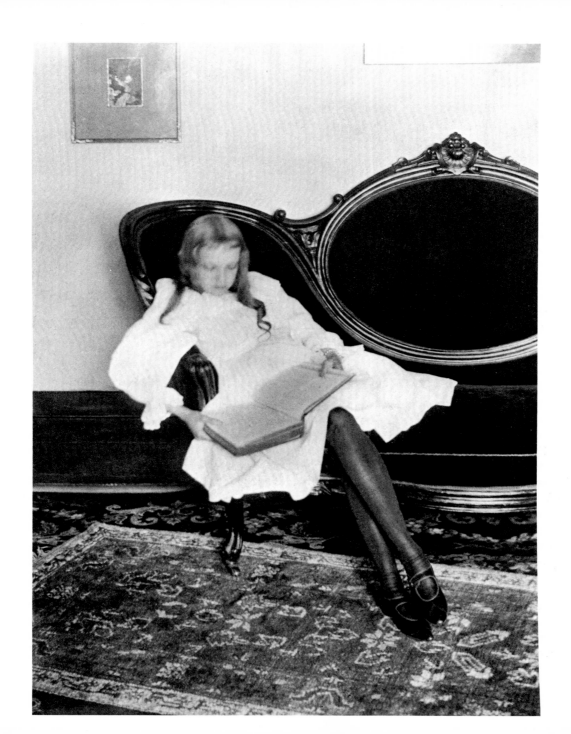

His reputation was already secure. In a 1904 article on White, Joseph Keiley prophesied to the audience of a British art journal:

> I have often wondered, when I reflected upon it, if when the last word has been written and the verdict of the critics and reviewers, as well as the work reviewed, has been submitted to the Tribunal of Time, whether the final and unreversible judgment will not be that the work of Clarence H. White was the best and most permanent produced in the first century of the application of photography to the production of original pictures.[13]

F. Holland Day, before the turn of the century, was even more succinct about White's gift as a photographer: "though not numerous, [his works] claim recognition in the very front rank of photography as a fine art. Indeed, I cannot refrain from naming Mr. White the only man of real genius known to me who has chosen the camera as his medium of expression."[14] An unknown Ohio novice in the mid-1890's, by 1906 White was recognized and admired in photographic circles everywhere.

After 1906 his work changed very little. Although he spent the last nineteen years of his life principally in New York, there is nothing in his pictures to suggest that he had even visited the city. Seeing the face and spirit of industrial America as unfriendly to his own spirit, he never turned his camera to the locomotive, the lathe, or to pulsating urban streetscapes. He continued instead to derive his inspiration from nature.

White earned enough money to get by during his first year and a half in New York by making further trips, in the Midwest and the South, to do portraits. Then in 1907 the opportunity came that freed him from this photographic commerce. He explained it this way:

> I took photography, as nine out of ten of the photographers do, as a hobby, and pursued it with all the enthusiasm of the amateur—so much so that a change of occupation became necessary. Photography then became my real work, but I was still anxious to keep the attitude of the amateur by doing the best in me. I believed in photography as an *expression for an artist*. This persistence led me into another field of photography, that of teaching.[15]

Arthur Wesley Dow, an early and constant friend of photography, hired White to teach the first courses in the subject at Columbia University, where Dow was the Art Department chairman. His education limited to a high school diploma and his artistry entirely self-taught, White understandably began his new career with some self-consciousness. His fears turned out to be unfounded as he quickly became famous as a teacher. His own production of photographs, however, fell victim to his increasingly heavy teaching duties. Though his output was small from 1907 until the very eve of his death, his vision shifted perceptibly toward bold abstract forms and patterns—no doubt in part as a result of his close

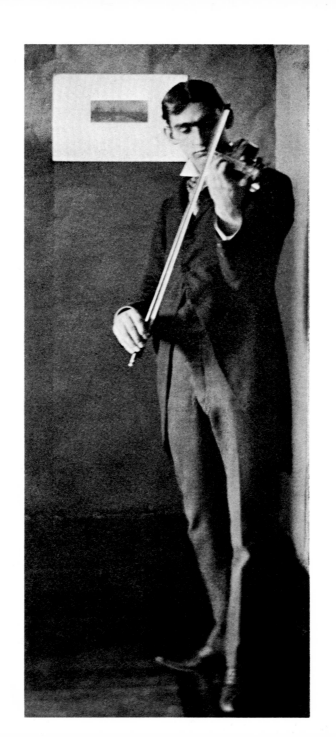

13

association with the abstract painter Max Weber.

White soon added to his Columbia teaching load by founding, largely by accident, his own school of photography. In 1905 the Whites had accepted the invitation of F. Holland Day to summer with him at his house in Maine. It was a happy and relaxing time, during which White did some of his best work, including the "Pipes of Pan," "The Wrestlers," the "Tree Toad" and "Boy Among the Rocks," and the Whites returned to Maine as Day's summer guests in 1908 and 1909. But White was earning no summer income to supplement his modest Columbia teaching salary. Then, in 1909, on a stroll through the woods near Day's home, he came across a deserted, semi-ruined nineteenth-century farmhouse. To say he fell in love with it is an understatement. When he returned to New York that fall, he could not get it out of his mind. In January, 1910, during a teaching break, he took a train to Maine and, standing in the snow, managed to persuade the incredulous owner, a Maine native, to sell him the house for $100 together with a plot of ground a hundred or so yards away on the Sheepscot River. An elderly ship's carpenter and a helper sawed the house in two, jacked it up and cranked it to its new location by the river with the use of a ship's windlass.

Max Weber, who had returned from Paris the year before and who, according to his own account, was unemployed and living almost exclusively on a diet of onions and pumpernickel, was persuaded to join the faculty of the new summer school in Maine, along with photographers F. Holland Day and Gertrude Käsebier. White's derelict home slowly took shape, and the school provided him and his family with both a small income and an annual vacation in the Maine they loved.

White's first school was variously named the Clarence H. White School of Modern Photography and the Seguinland School of Photography, so called after the Victorian hotel on Georgetown Island that housed the students. In 1914 White would expand his teaching by starting another school in New York, again with Max Weber as a co-founder. The school was always located in his home, first at 230 East 11th Street—a brownstone next to, and owned by, the lively St. Mark's-in-the-Bouwerie—and then in the handsome Washington Irving House at 122 East 17th Street. In 1920 the school transferred to 460 West 144th Street, where it remained until White's death and for fifteen years thereafter.

White's schools never made him much of a living. "I had the very strong impression that White was no wolf after money, and that there were financial troubles," his former student Ralph Steiner confided to the writer.[16] Mrs. White, who held everything together by sheer hard work, sacrifice and the force of her character, spoke eloquently in her diary about the school's and the family's finances: "We simply have never made a living: we are always *sorely* pressed, & have gotten pleasure out of the work Clarence does & the people we meet, simply by constantly exerting

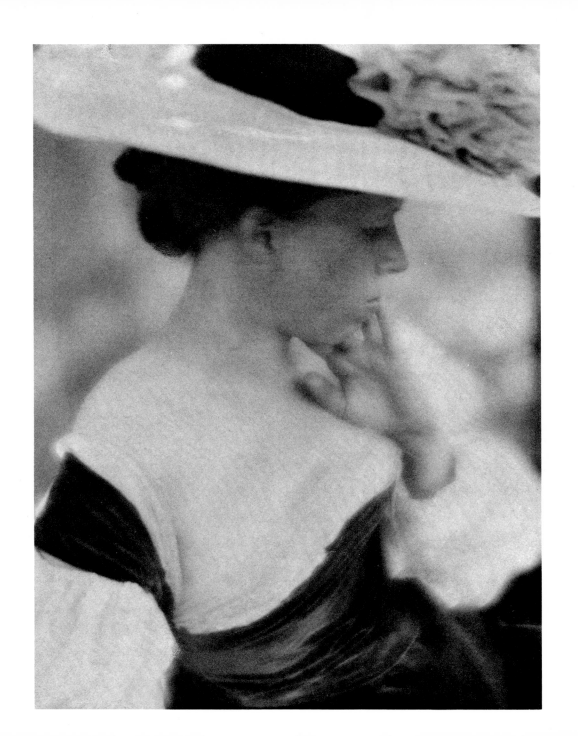

15

ourselves to the limit."[17] White summed up his motives by saying: "In view of the fact that I am the director of a School of Photography, we are not a commercial institution, even though I feel that we have the privilege of making a living by it, which we do not. It is exactly our standard and has always been to plant the 'seed of enthusiasm' above any thought of profit in our School."[18] White made ends meet only by undertaking a gargantuan teaching schedule. To his own schools and his job at Columbia he added the position of lecturer in art photography at the Brooklyn Institute of Arts and Science and took special students outside his regular teaching schedule. By teaching day and night the year round he was able to get by—while building a solid and lasting reputation as one of the great teachers of photography.

White's teaching was, like his photography, subtle and refined. "Why he was extraordinary has puzzled me ever since because he didn't do anything," recalled Dorothea Lange, one of White's students. "He was an inarticulate man, almost dumb, and he'd hesitate, he'd fumble. But the point is that he gave everyone some feeling of encouragement in some peculiar way. I don't think he mentioned technique once, how it's done, or shortcuts or photographic manipulations. It was to him a natural instrument and I suppose he approached it something like a musical instrument which you do the best you can with when it's in your hands."[19]

If White's own creativity was submerged by his career as a teacher after 1907, such students as Karl Struss, Margaret Bourke-White, Dorothea Lange, Laura Gilpin, Anton Bruehl, Ralph Steiner, Doris Ulmann and Paul Outerbridge to some degree offset this loss to photography. In addition, White never abandoned his gentle but effective role as a promoter of photography, which he had pioneered in the 1899 Newark, Ohio, exhibition of American pictorialists. He was the largest single exhibitor in the 1910 International Exhibition of Pictorial Photography at the Albright Art Gallery in Buffalo, and he either exhibited his work in or helped organize nearly every major photographic exhibition from the Albright in 1910 until his sudden death in 1925. In 1915, along with Käsebier and Coburn, he was a cofounder of the Pictorial Photographers of America, of which he became the first president.

World War I was a wrenching time for the Whites. Their second son, Maynard, then a sophomore at Brown, enlisted in the army and was involved in the fighting in France. A number of White's old Socialist friends were imprisoned for speaking out against the war. And like many others, White was disillusioned by the harsh terms of the Treaty of Versailles. In the 1920's, however, the skies brightened somewhat. Maynard, who had survived the war, was married in 1923 and took a job in Mexico. Soon White was looking forward to a trip to Mexico City and the chance there to take some photographs of his own. As he jubilantly wrote F. Holland Day, "I think I will find an *impetus* that

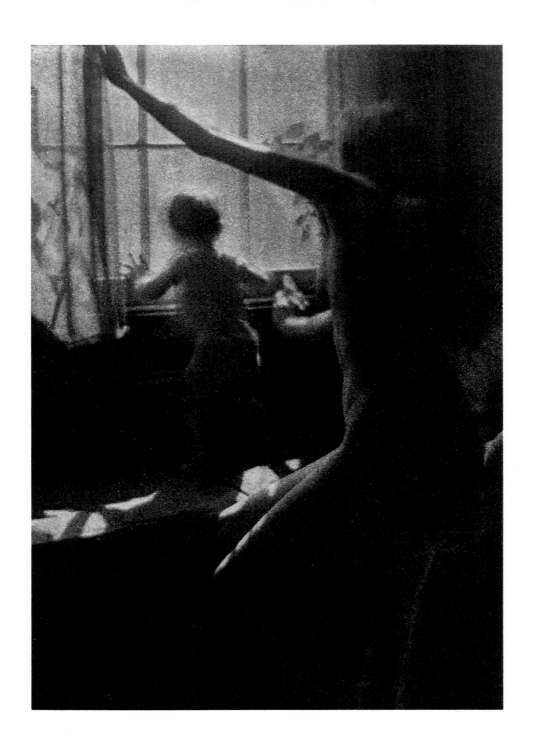

should be profitable to *my own work* if in the short stay I make I can get hold of it."[20] This hopefulness is well illustrated by a number of photographic images which he made on the occasion of a class trip to the Croton dam and reservoir near New York and lunch at the Mikado Inn. These two stops in a single day's outing witnessed a remarkable outpouring of his art—remarkable in quantity as well as quality. The images run the spectrum of his life's work, from the delicate subtlety of his early photographs to the stronger patterns and abstract designs that began to appear in his photographs more frequently toward the end of his life. He made a portfolio of small but stunning platinum prints from that one day of April 18, 1925.

In July of the same year White and several of his students spent a pleasant and productive week in Mexico City when disaster struck. White was felled by what doctors diagnosed as a heart attack brought on by the city's altitude. Twenty-four hours later White was dead from a ruptured arterial aneurism of the heart. All that was left was for Maynard to escort his father's body back to his native Ohio for burial.

White's sudden and unexpected death was of course an enormous shock to Jane White, but her determination to continue the school of photography did not flag, and through her efforts it survived for two decades. Her son Clarence Jr. joined the faculty in 1931 and became its sole director by the end of the decade. Many old friends such as Max Weber, Edward Steichen and Gertrude Käsebier continued to lecture along with former students such as Anton Bruehl and Ralph Steiner, none working for pay. New faces appeared, too—people like Ansel Adams and Beaumont Newhall who, as Jane White noted in her diaries, combined a love of art with a warm humanity.

It is difficult to assess the lasting importance of any man's art; it is especially hard for the artist's grandson. But it can be said that a half-century after White's death his photographs have endured and seem likely to continue to be admired. In a recent assessment, John Szarkowski said, "of the artist-photographers of 1900, he seems to be the best."[21] His impact as a teacher has lived in the work of his students—and in the students whom they in turn have trained. As Dorothea Lange put it, "He touched lives. And all that I've said about him is probably wrapped up in that phrase. He had an uncanny gift of touching people's lives, and they didn't forget it."[22] Perhaps the most important thing that can be said of Clarence White is that he spent his life serving his art and not himself. Again, in what turned out to be the eleventh hour of her own life, Dorothea Lange remembered this gentle, impractical but intensely photographic soul: "This was a man who lived a kind of an unconscious, instinctive, photographic life. He didn't ever seem to know exactly that he knew where he was going, but he was always in it."[23]

Maynard P. White

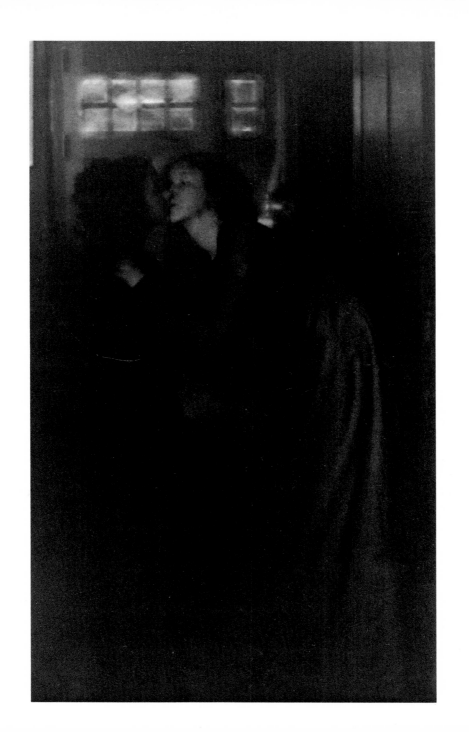

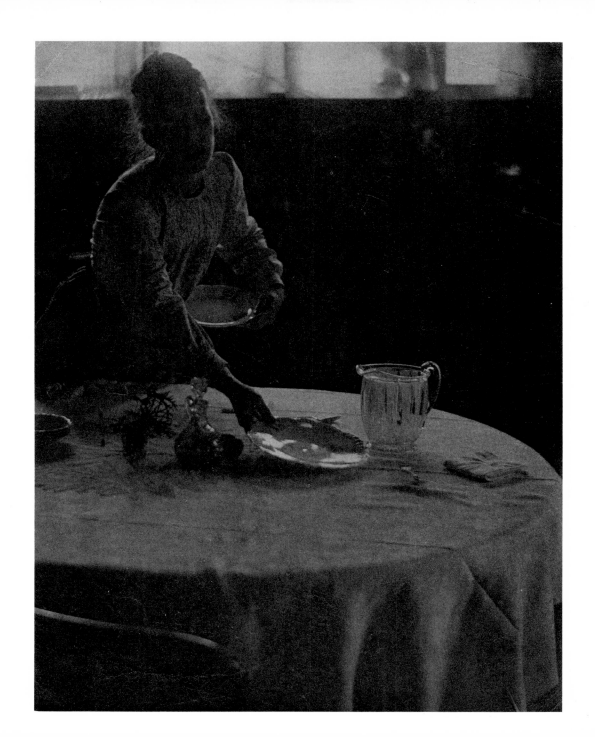

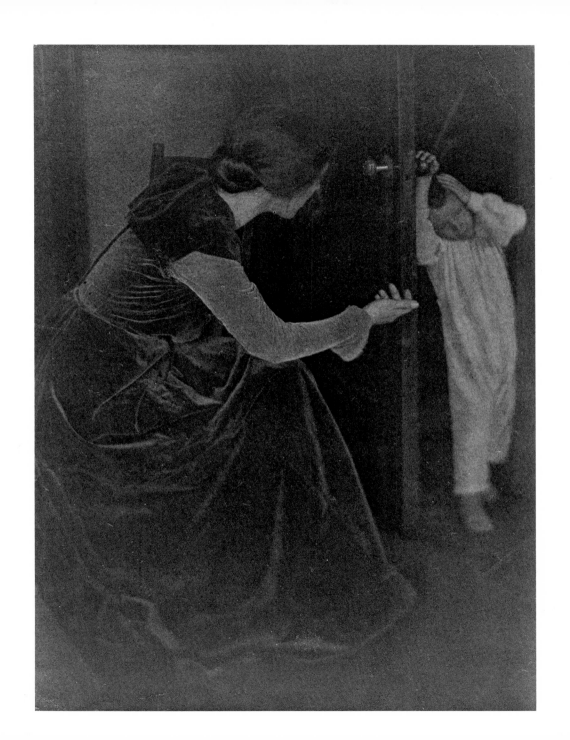

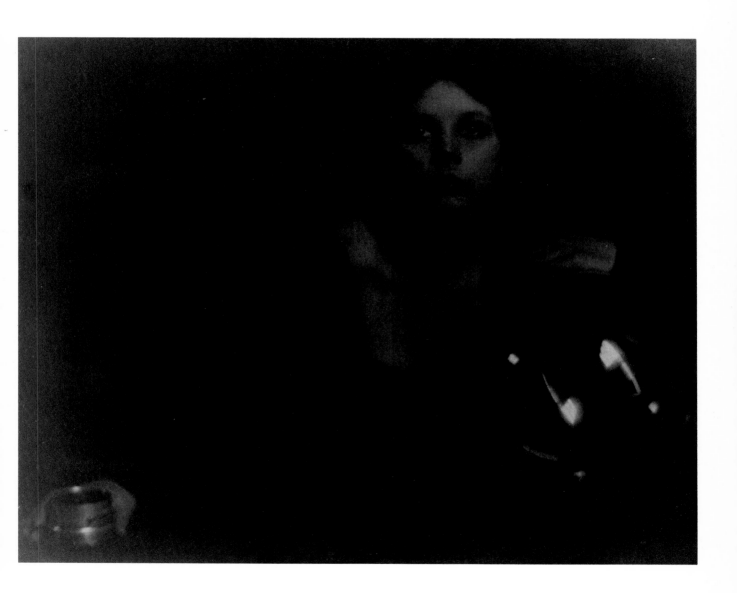

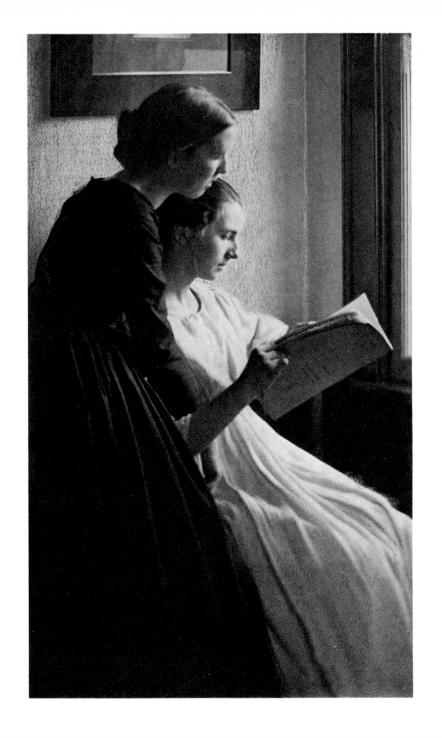

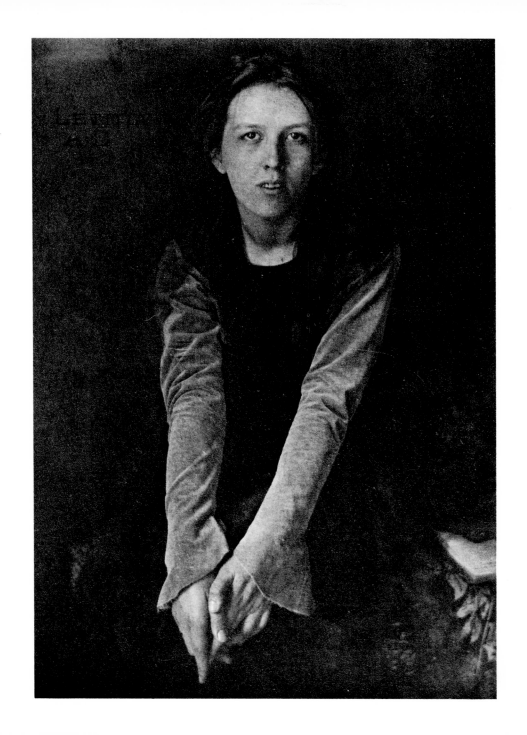

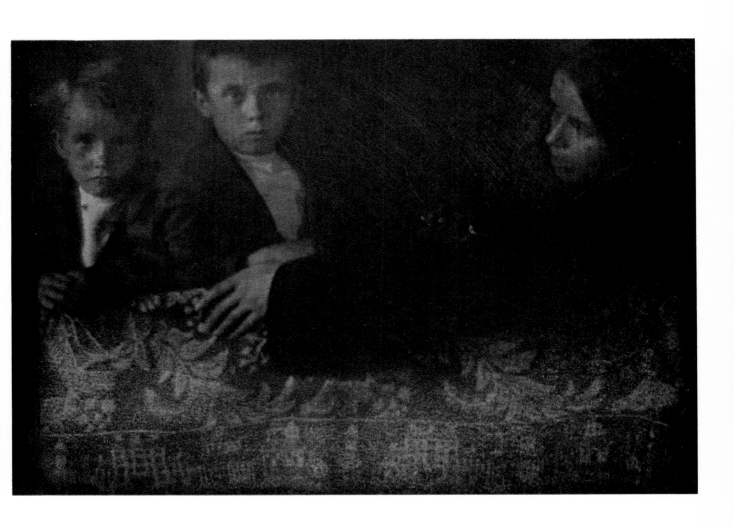

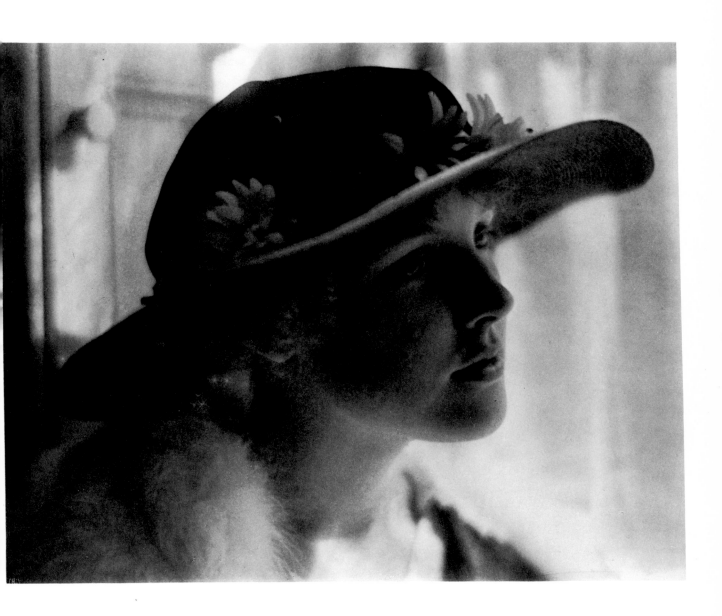

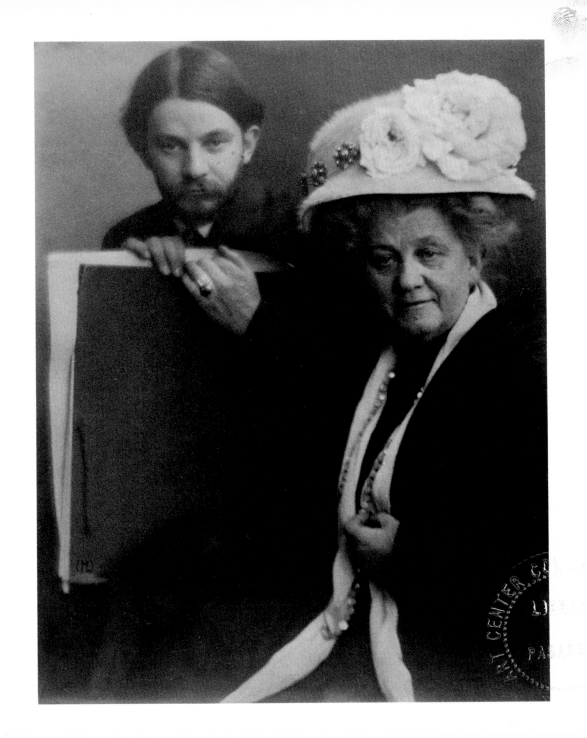

35

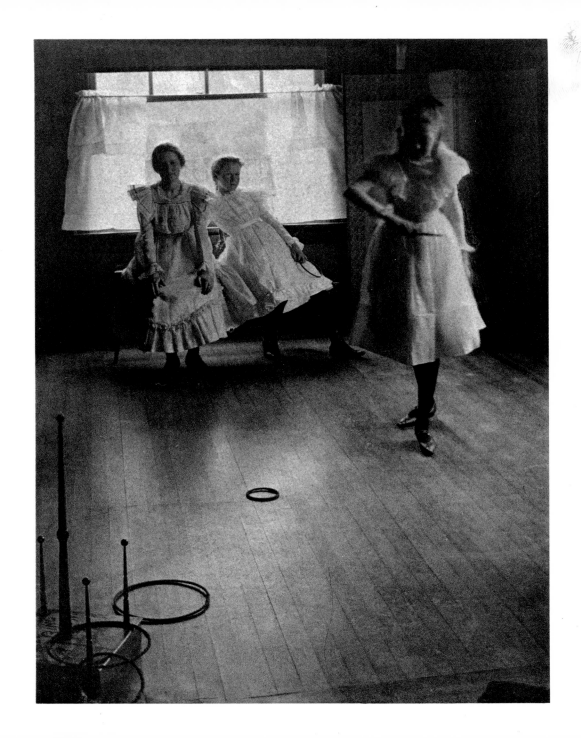

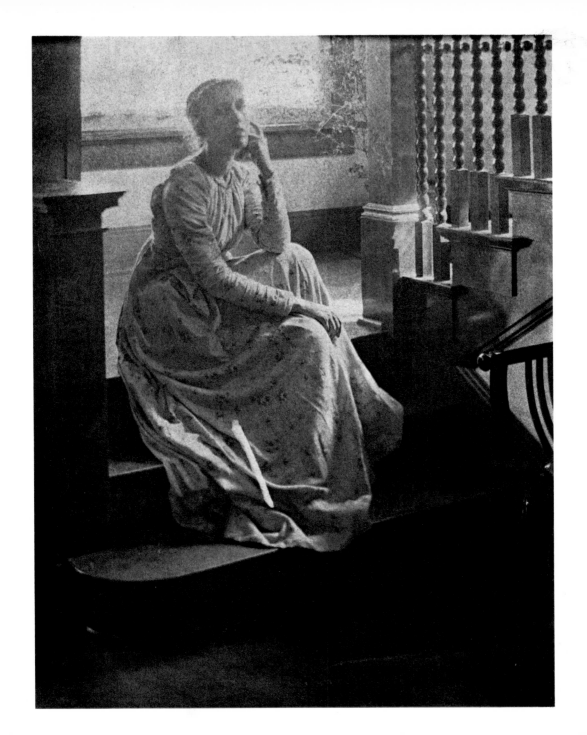

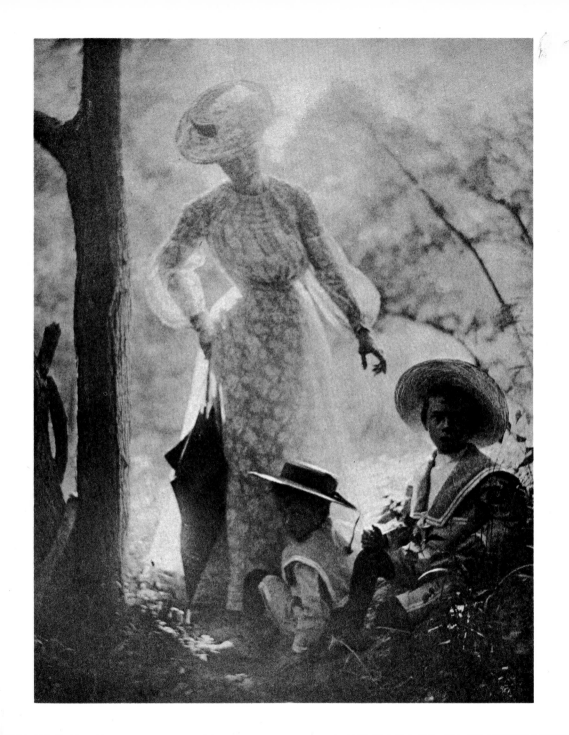

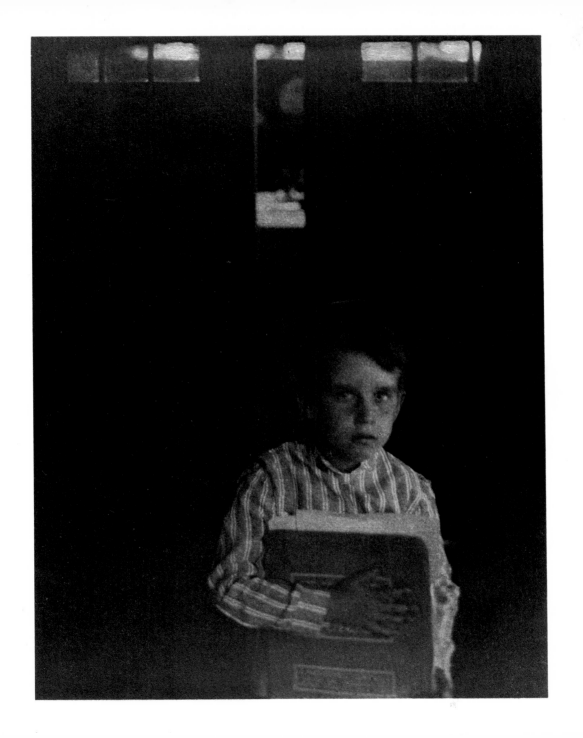

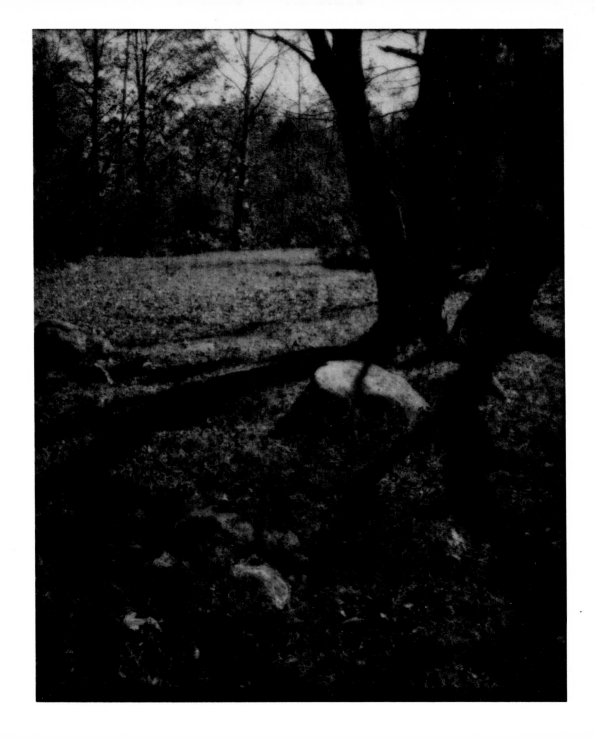

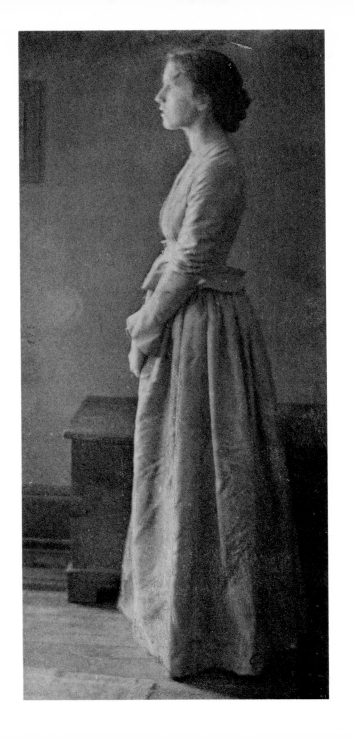

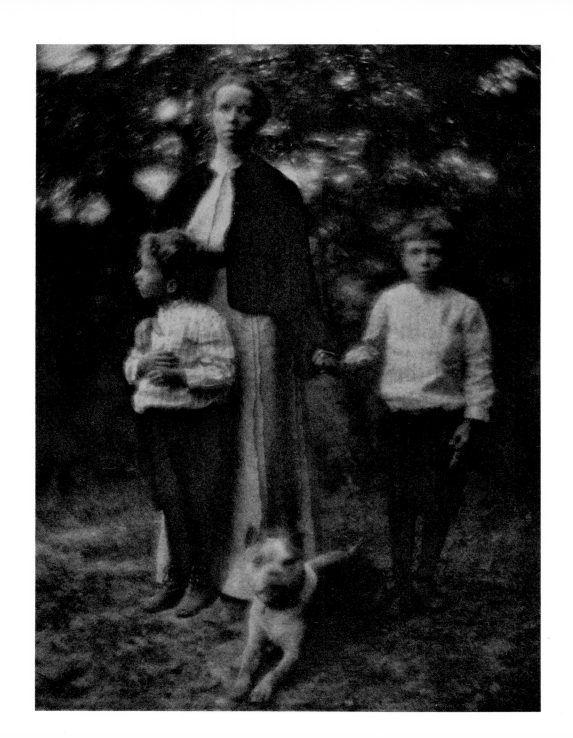

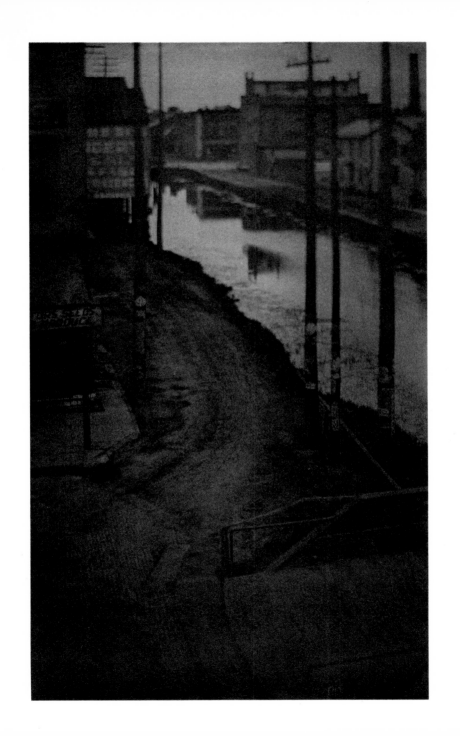

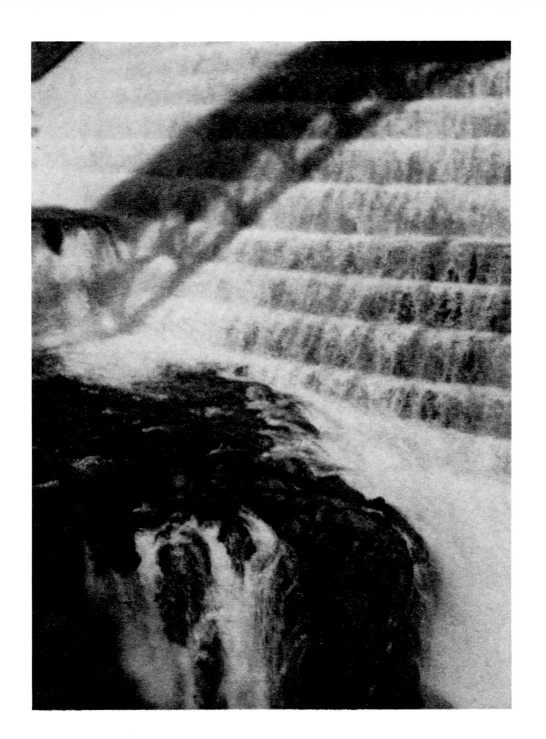

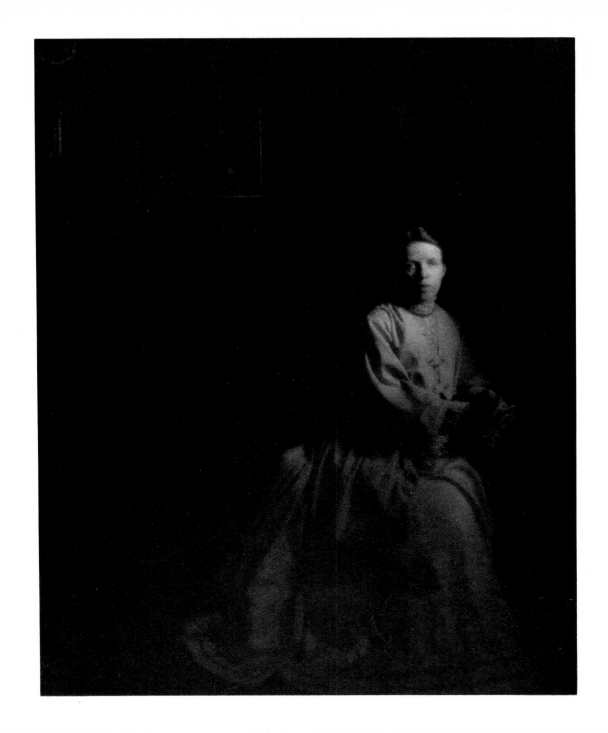

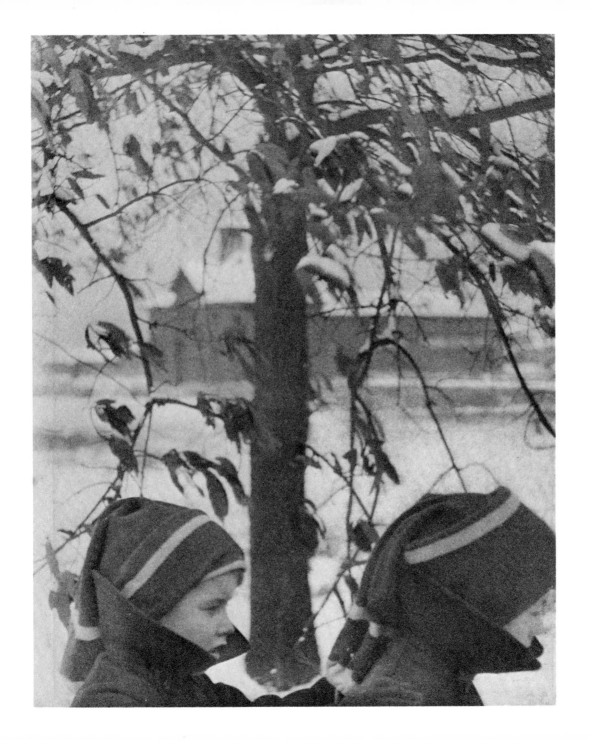

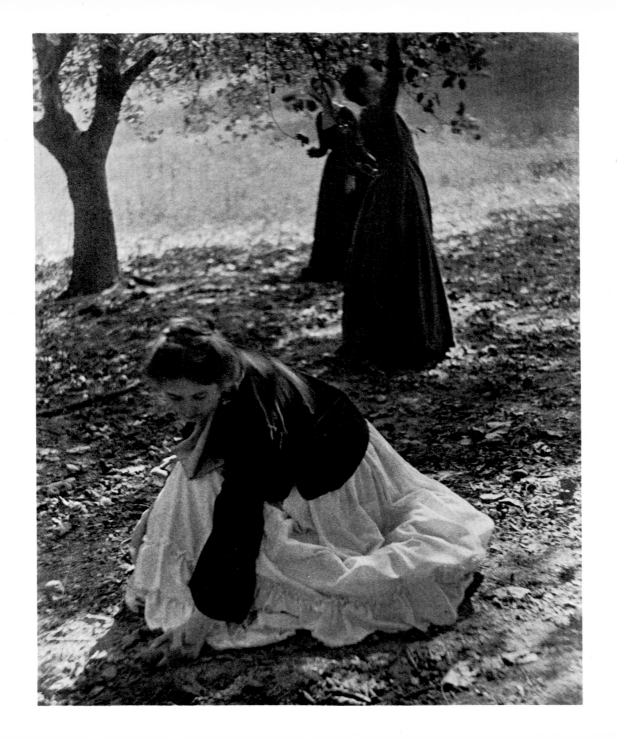

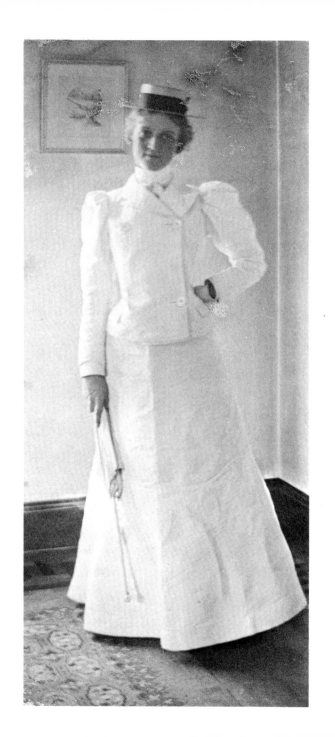

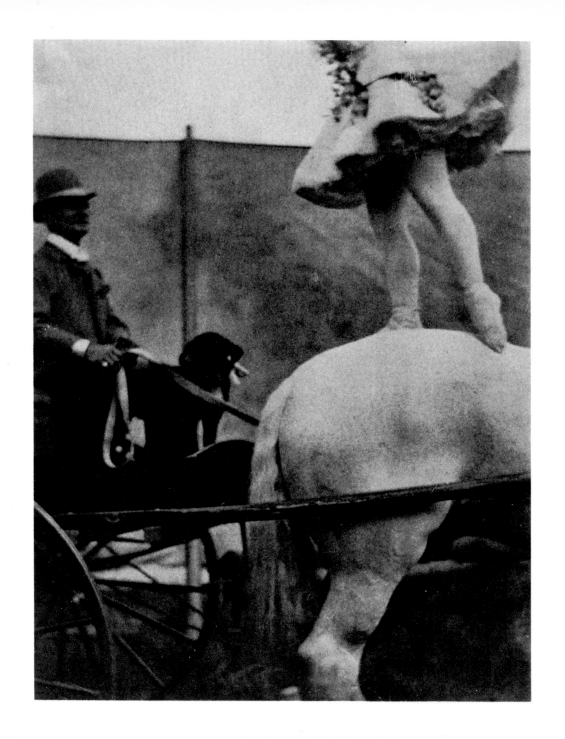

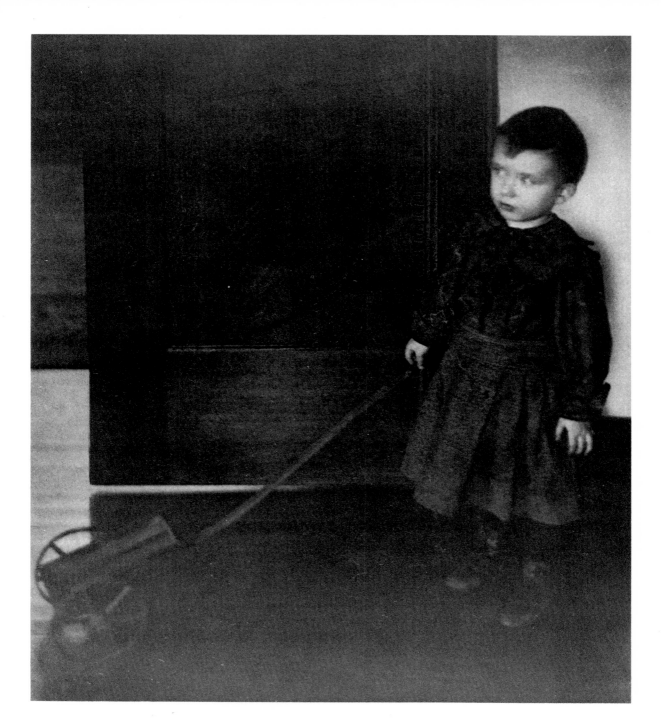

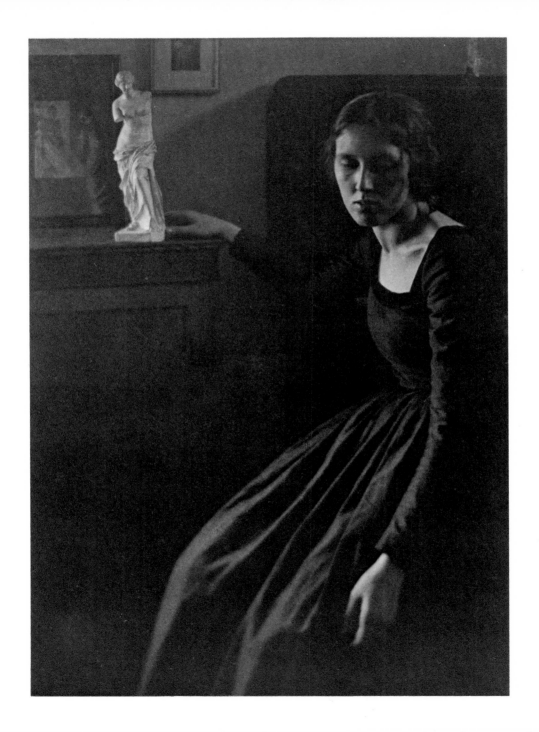

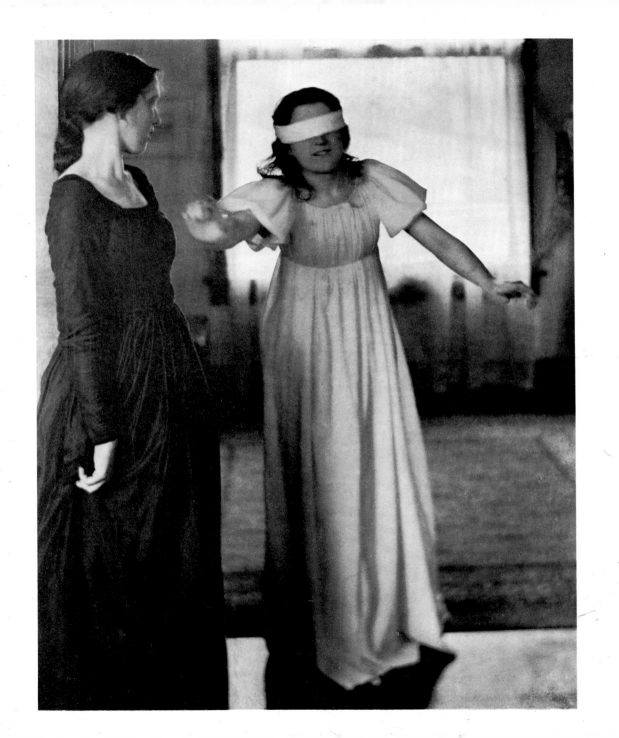

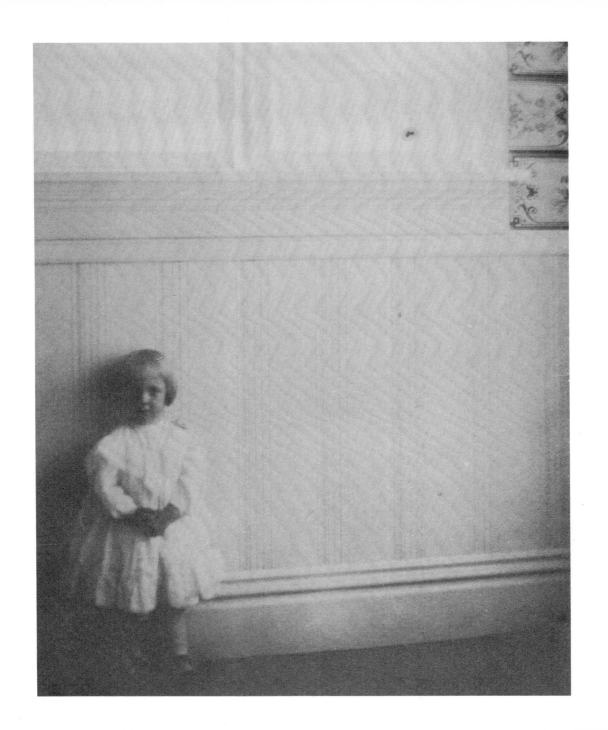

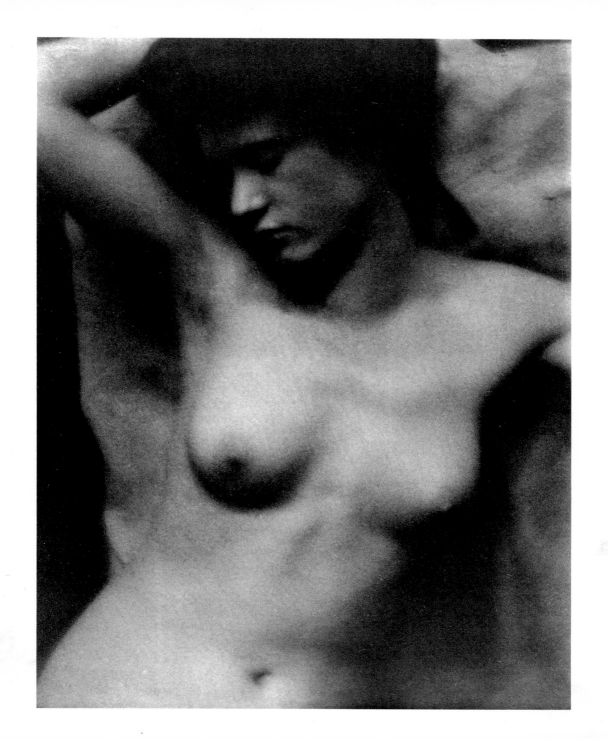

73

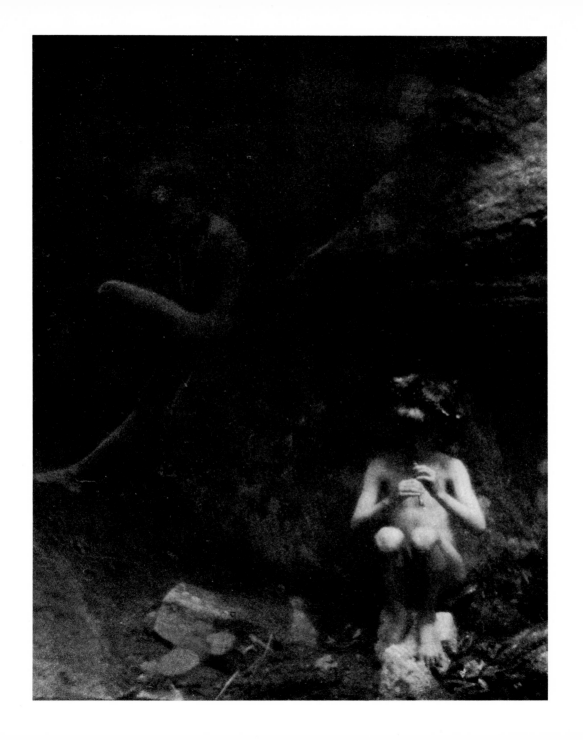

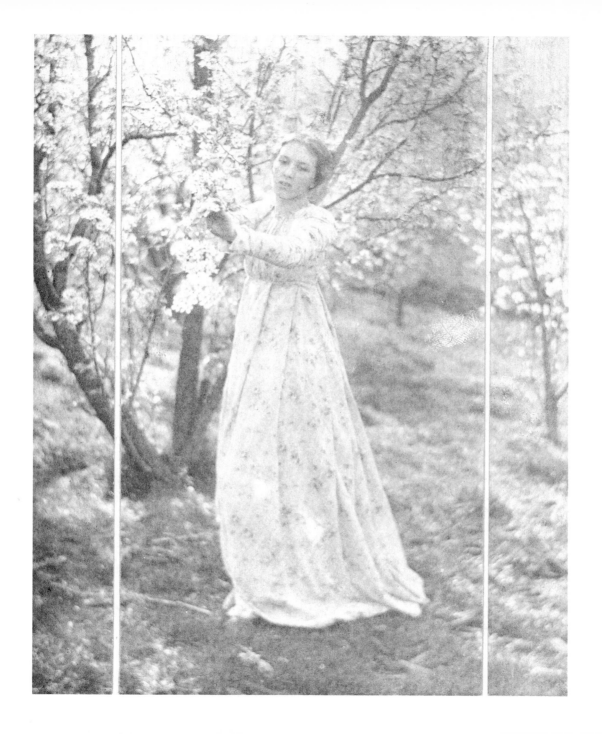

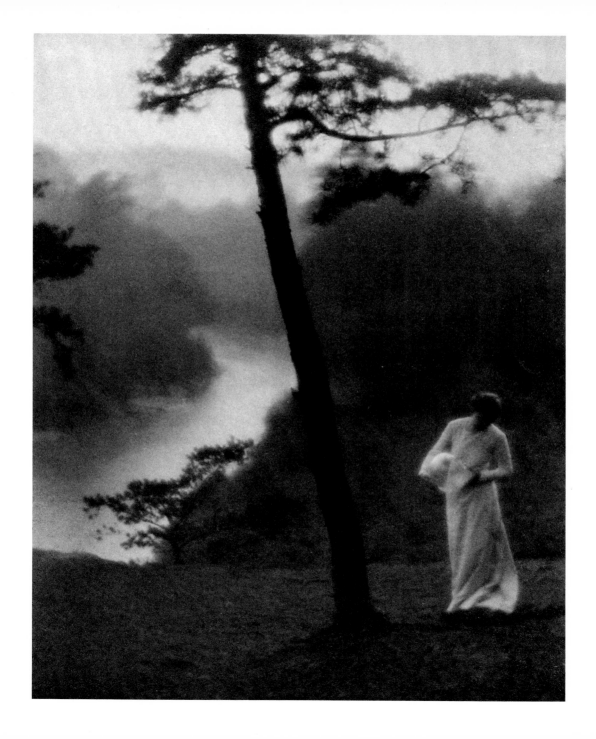

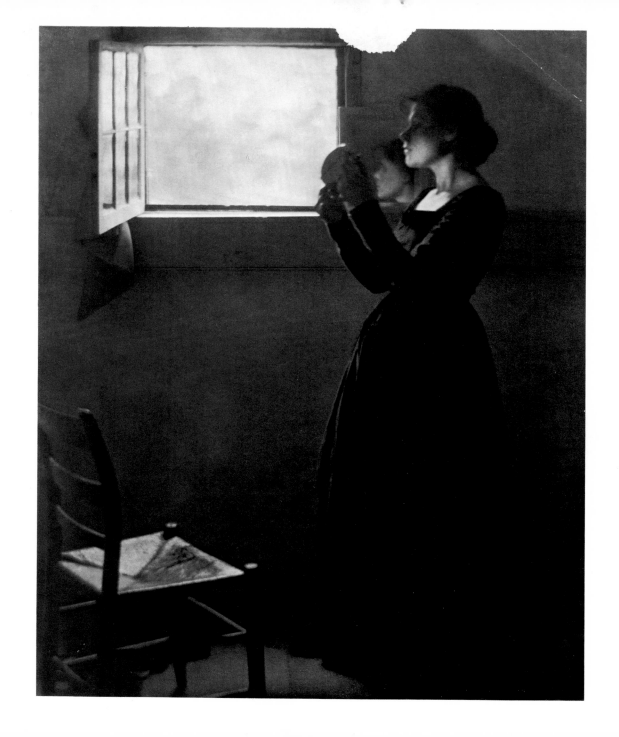

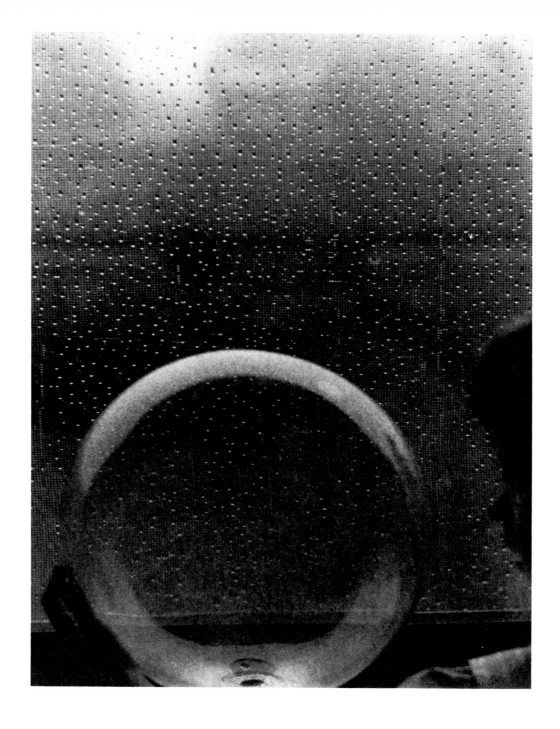

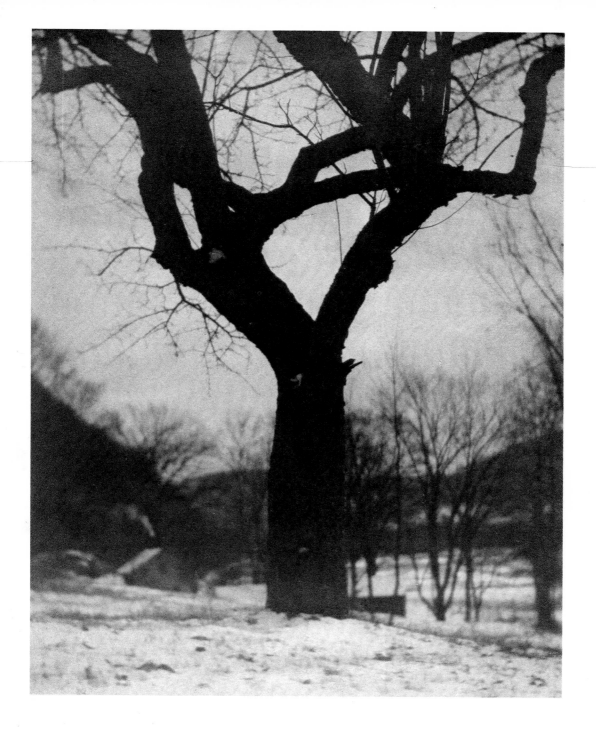

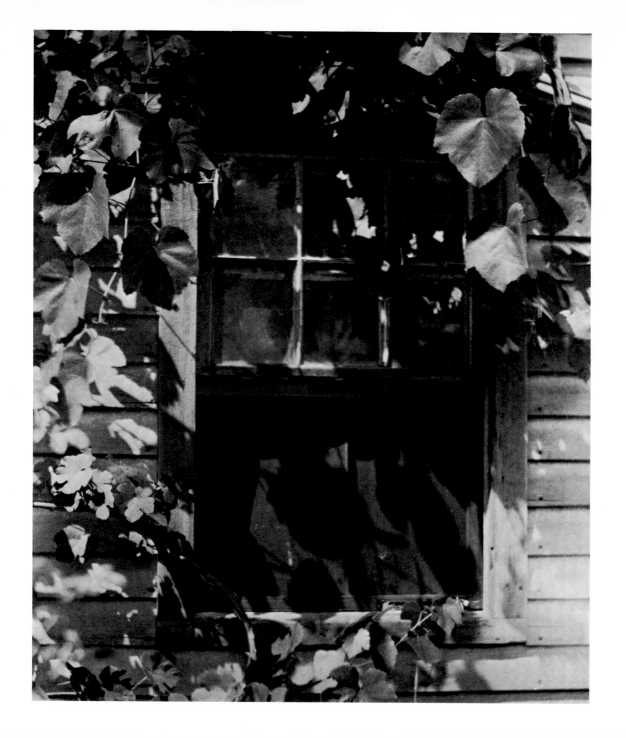

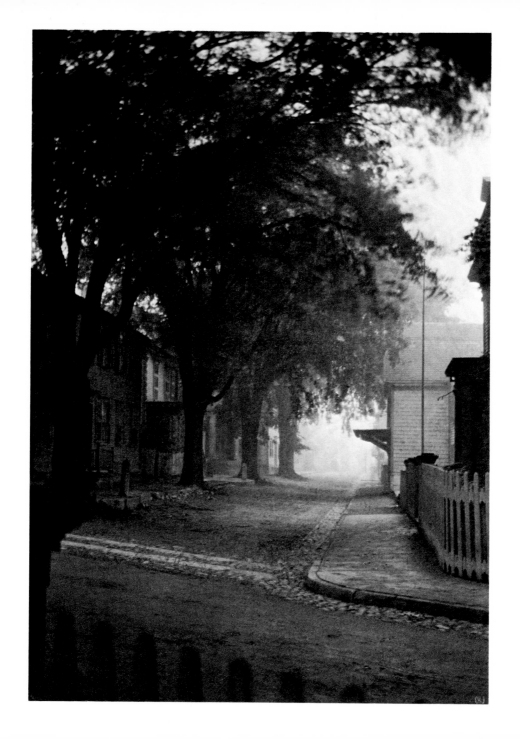

NOTES

1. Alvin L. Coburn, *Alvin Langdon Coburn, Photographer* (New York: 1966), p. 88.
2. John Szarkowski, *Looking at Photographs: 100 Pictures from the Collection of The Museum of Modern Art* (New York: 1973), p. 50.
3. *Memoir of Max Weber: An Interview Conducted by Carol S. Gruber* (New York: 1958), pp. 276–277.
4. Clarence H. White, "The Progress of Pictorial Photography," *Annual Report of the Pictorial Photographers of America* (New York: 1918), p. 14.
5. Nancy L. Lonsinger "County's Most Famous Photographer Was Revolutionary in His Technique," *The Coshocton* (Ohio) *Tribune* (January 16, 1972).
6. Undated and untitled typescript with pen and pencil corrections by Clarence H. White, probably written 1918–19. Collection of the author.
7. Beaumont Newhall to Maynard P. White, Jr. (September 14, 1973).
8. Ralph Steiner to Maynard P. White, Jr. (February 24, 1973).
9. Beaumont Newhall to Maynard P. White, Jr. (September 14, 1973).
10. Undated and untitled typescript with pen and pencil corrections by Clarence H. White.
11. Undated note from Verona Martin to accompany the gift of the April 4, 1904, portrait of herself by Clarence H. White, to the collection of the Licking County (Ohio) Historical Society.
12. *The Newark* (Ohio) *Advocate* (November 19, 1898).
13. Joseph T. Keiley, "Clarence H. White," *Photography* (June 25, 1904), p. 566.
14. Ellen F. Clattenburg, *The Photographic Work of F. Holland Day* (Wellesley: 1975), p. 41.
15. John W. Gillies, *Principles of Pictorial Photography* (New York: 1923), p. 25.
16. Ralph Steiner to Maynard P. White, Jr. (February 24, 1973).
17. Diary of Jane Felix White, from July 3, 1915, through January 17, 1917. Entry of October 13, 1915. Collection of the author.
18. "A Letter from Clarence White," *Abel's Photographic Weekly* (September 22, 1923), n.p. The letter is in a clipping from a scrapbook compiled by Jane Felix White. Collection of the author.
19. Dorothea Lange, *The Making of a Documentary Photographer: An Interview Conducted by Suzanne Reiss* (Berkeley, 1968), pp. 37–40.
20. Clarence H. White to F. Holland Day (June 5, 1925). F. Holland Day Archive, Day House, Norwood Historical Society, Norwood, Mass.
21. Szarkowski, *Looking at Photographs,* p. 50.
22. Lange, *Documentary Photographer,* p. 40.
23. *Ibid.,* p. 42.

PHOTOGRAPHS

Front Cover: The Sisters, 1900. Private Collection.

Frontispiece: Clarence H. White by Alvin Langdon Coburn, 1912. Private Collection.

11. Miss Grace, 1898. The Museum of Modern Art, New York.

13. The Violinist, 1897. The Museum of Modern Art, New York.

15. Jane Felix White, *c.* 1905. The Library of Congress, Washington, D.C.

17. Nude with Baby, 1912. The Library of Congress, Washington, D.C.

19. The Kiss, 1904. The Library of Congress, Washington, D.C.

21. Untitled (Jane White setting table), *c.* 1900. Private Collection.

23. The Bashful Child, 1899. The Library of Congress, Washington, D.C.

25. Symbolism of Light, 1907. The Library of Congress, Washington, D.C.

27. The Readers, 1897. The Licking County Historical Society, Newark, Ohio.

29. Letitia Felix, 1901. Private Collection.

31. Family Group (Maynard, Lewis, and Jane White), *c.* 1899. Private Collection.

33. Justine Johnson, Actress, 1916. The Museum of Modern Art, New York.

35. Alvin Langdon Coburn and His Mother, *c.* 1907. International Museum of Photography at George Eastman House, Rochester, New York.

37. Ring Toss, 1899. The Library of Congress, Washington, D.C.

39. Untitled (Letitia Felix seated on stairs), *c.* 1897–98. Private Collection.

41. Family Group, *c.* 1899. Private Collection.

43. Boy with Camera Work, 1903. Helios Gallery.

45. Woodland Scene, *c.* 1905. The Licking County Historical Society, Newark, Ohio.

47. The Puritan, 1899. The Licking County Historical Society, Newark, Ohio.

49. Family Group, *c.* 1904. Private Collection.

51. Telegraph Poles, 1898. The Licking County Historical Society, Newark, Ohio.

53. Falls and Shadow, Croton Dam, 1925. Private Collection.

55. Mrs. Clarence H. White, 1905. Private Collection.

57. Boys Going to School, *c.* 1904. Private Collection.

59. The Orchard, 1902. Private Collection.

61. Portrait of Mrs. H., 1898. The Library of Congress, Washington, D.C.

63. The Circus Rider, *c.* 1902–06. Private Collection.

65. Boy with Wagon, 1898. The Library of Congress, Washington, D.C.

67. Lady in Black with Statuette, 1898. The Library of Congress, Washington, D.C.

69. Blind Man's Buff, 1898. The Museum of Modern Art, New York.

71. Untitled (Child standing by wall), *c.* 1905. Private Collection.

73. Torso, 1907. Clarence H. White and Alfred Stieglitz. The Library of Congress, Washington, D.C.

75. The Pipes of Pan, 1905. Private Collection.

77. Spring—A Triptych, 1898. The Library of Congress, Washington, D.C.

79. Morning, 1905. Private Collection.

81. The Mirror, 1912. The Museum of Modern Art, New York.

83. Raindrops, 1903. Private Collection.

85. The Tree—Winter, *c.* 1919–24. Private Collection.

87. The Studio Window, *c.* 1920. The Museum of Modern Art, New York.

89. New England Street, 1907. The Museum of Modern Art.

CHRONOLOGY

1871. Born April 8, West Carlisle, Ohio.

1887. Moves with family to Newark, Ohio, where father works as traveling salesman for wholesale grocery firm.

1890. Graduates from high school, ending formal education. Takes job as bookkeeper for wholesale grocery firm.

1893. Marries Jane Felix. Wedding trip to Chicago to see World's Columbian Exposition; first contact with major artists of the day. Takes first photographs.

1894. Begins serious work with photography.

1895. Son Lewis Felix born.

1896. Exhibits photographs at Camera Club, Fostoria, Ohio. Son Maynard Presley born.

1897. Awarded Gold Medal at Ohio Photographers exhibition. Receives two diplomas at Detroit Camera Club show.

1898. Awarded Grand Prize at First Annual International Salon and Exhibition of Pittsburgh Amateur Photographers' Society. Founds Newark (Ohio) Camera Club and organizes club's first exhibition. Shows own work as well as that of other nationally known amateur photographers. Participates in First Philadelphia Photographic Salon; meets Gertrude Käsebier, F. Holland Day, Joseph Keiley, William Merritt Chase and Alfred Stieglitz.

1899. Participates in London's Photographic Salon organized by Linked Ring. Elected honorary member of Camera Club of New York; Alfred Stieglitz organizes one-man show of White's work. Organizes Second Newark Camera Club Exhibition, where every major American photographer is represented including Frenchman Robert Demachy; this group forms nucleus of Photo-Secession three years later.

1900. Exhibits in London and United States. Elected to membership in Linked Ring. Exhibits and serves as member of the jury for Chicago Photographic Salon;

encourages Edward Steichen to submit his work there. Gives Steichen letter of introduction to Alfred Stieglitz.

1901. Charles H. Caffin dedicates chapter in *Photography as a Fine Art* to the work of White and William B. Dyer.

1902. Founding member of Photo-Secession. Continues to exhibit in America and Europe.

1903. Participates in Photo-Secession shows. Five works reproduced in *Camera Work,* 3.

1904. Leaves job with grocery firm to travel, mainly in Midwest; earns living entirely from photography, mainly portraiture. Meets Stephen Marion Reynolds family in Terre Haute, Indiana; participates in "Red House" salons with such figures as Eugene Victor Debs, Clarence Darrow and Horace Traubel. Wins gold medal at First International Salon of Art Photography, The Hague, for best genre picture.

1906. Exhibits work in joint show with Gertrude Käsebier at "291" gallery. Moves family to New York City.

1907. Son Clarence Hudson, Jr., born. Ceases all commercial work except portraiture; to earn a living, begins new career as teacher of photography. Own work declines due to teaching schedule, a situation not reversed until last year of life. Remains seminal force in photography through dissolution of Photo-Secession in 1910. Co-founds and serves as first president of Pictorial Photographers of America. Participates in and helps organize most major exhibitions until his death in 1925.

1908. Appointed instructor in photography at Brooklyn Institute of Arts and Sciences. Sixteen works reproduced in *Camera Work,* 23.

1909. Four works reproduced in *Camera Work,* 27.

1910. Founds summer school of photography at Georgetown Island, Maine, with F. Holland Day, Gertrude Käsebier and co-founder Max Weber.

1912. Quarrels with Alfred Stieglitz and leaves Photo-Secession.

1913. *Men of Mark,* by Alvin Langdon Coburn, includes photograph of White as one of five Americans represented.

1914. Founds Clarence H. White School of Photography in New York. Students include Doris Ulmann, Anton Bruehl, Paul Outerbridge, Laura Gilpin and Ralph Steiner.

1916. Founds and serves as first president of Pictorial Photographers of America.

1918. Organizes and exhibits in Pictorial Photographers of America exhibition, which travels throughout United States.

1920. Named a director of Art Center, Inc., New York.

1921. Resigns position as instructor at Brooklyn Institute.

1925. Dies July 8 while leading student trip to Mexico City.

SELECTED BIBLIOGRAPHY

BOOKS AND CATALOGUES

Anderson, Paul L., *The Fine Art of Photography.* Philadelphia: J. B. Lippincott & Co., 1919.

Branciaroli, Cathleen A., William I. Homer, Frances Orlando, and Maynard P. White, Jr., *Symbolism of Light: The Photographs of Clarence H. White.* Wilmington: Delaware Art Museum, 1977.

Bunnell, Peter C., *The Significance of the Photography of Clarence Hudson White (1871–1925) in the Development of Expressive Photography.* Master's Thesis, Ohio University, 1961.

Caffin, Charles H., *Photography as a Fine Art.* New York: 1901.

Coburn, Alvin Langdon, *Alvin Langdon Coburn, Photographer.* Edited by Helmut and Alison Gernsheim. New York: Frederick A. Praeger, 1966.

Corn, Wanda M., *The Color of Mood: American Tonalism, 1880–1910.* San Francisco: M. H. De Young Memorial Museum and the California Palace of the Legion of Honor, 1972.

The Darkness and the Light: Photographs by Doris Ulmann. Preface by William Clift. Millerton, N.Y.: Aperture, Inc., 1974.

Doty, Robert. *Photo-Secession: Photography as a Fine Art.* Rochester, N.Y.: George Eastman House, 1960.

Exhibition of Photographs by Clarence H. White, Newark, Ohio. Introduction by Ema Spencer. New York: Camera Club of New York, c1900.

Green, Jonathan (ed.), *Camera Work: A Critical Anthology.* Millerton, N.Y.: Aperture, Inc., 1973.

Harvith, John and Susan E., *Karl Struss: Man with a Camera.* Bloomfield Hills, Mich.: Cranbrook Academy of Art Museum, 1976.

Homer, William I., *Alfred Stieglitz and the American Avant-Garde.* Boston: New York Graphic Society, 1977.

Lange, Dorothea, *The Making of a Documentary Photographer: An Interview Conducted by Suzanne Riess.* Berkeley, Calif.: University of California Regional Oral History Office, The Bancroft Library, 1968.

Maddox, Jerald C., *Photographs of Clarence H. White.* Lincoln, Neb.: University of Nebraska Art Galleries, 1968.

Memorial Exhibition of the Work of Clarence H. White. New York: The Art Center, 1926.

Norman, Dorothy, *Alfred Stieglitz: An American Seer.* New York: Random House, 1973.

The Painterly Photograph. Text by Weston Naef. New York: The Metropolitan Museum of Art, 1973.

The Photographic Work of F. Holland Day. Introduction and catalogue by Ellen Fritz Clattenburg. Wellesley, Mass.: Wellesley College Museum, 1975.

Steichen, Edward J., *A Life in Photography*. Garden City, N.Y.: Doubleday & Co., 1963.

Szarkowski, John, *Looking at Photographs: 100 Pictures from the Collections of The Museum of Modern Art*. New York: The Museum of Modern Art, 1973.

Weber, Max, *Essays on Art*. New York: William Edwin Rudge, 1916.

White, Maynard P., Jr., *Clarence H. White: A Personal Portrait*. Ann Arbor, Mich.: University Microfilms International, 1975.

PUBLICATIONS WITH PHOTOGRAPHIC ILLUSTRATIONS BY CLARENCE H. WHITE

Bacheller, Irving, *Eben Holden*. Boston: 1900.

Barnard College Calendar of 1912. New York: Barnard College, 1911.

Billman, Ira, *Songs of All Seasons*. Indianapolis, 1904.

Laurvik, J. Nilsen, "The Pipes of Pan." *Metropolitan Magazine* (July 1909), 425–30.

Morris, Clara, "Beneath the Wrinkle." *McClure's Magazine*. (February 1904): 429–34.

Morris, Gouverneur, "Newport the Maligned." *Everybody's Magazine* (September 1908), 311–25.

W.D.J., "The Little Lady: An Appreciation of Maud Adams." *The Burr McIntosh Monthly* (June 1909).

White, Clarence H., "The House That Moved to the Sea." *Woman's Home Companion* (July 1924), 78, 84.

ARTICLES ABOUT CLARENCE H. WHITE

Beatty, John W., "Clarence H. White—An Appreciation." *Camera Work*, 9 (January 1905), 48–49.

Bicknell, George, "The New Art in Photography: The Work of Clarence H. White." *The Craftsman*, 9 (January 1906), 495–510.

Bunnell, Peter C., "Clarence H. White." *Camera*, 51 (November 1972), 23–40.

Caffin, Charles H., "Clarence H. White." *Camera Work*, 3 (July 1903), 15–17.

———, "Clarence H. White." *Camera Work*, 23 (July 1908), 6–7.

"The Clarence White Exhibition." *Photo-Era*, 4 (January 1900), 23–24.

"Clarence H. White Memorial Exhibition." *Photo-Miniature*, 17 (May 1926), 335–36.

"Clarence H. White School of Photography." *The Outlook*, 114 (September 1916), 97–99.

Deschin, Jacob, "Viewpoint. Father, Teacher, Photographer: Clarence H. White." *Popular Photography*, 69 (December 1971), 24, 26, 156.

Dickson, Edward R., "Clarence H. White—A Teacher of Photography." *Photo-Era*, 30 (January 1913), 3–6.

"Enthusiastic Photo Secessionist, Clarence White." *The Ohio State Journal* (Columbus, O.), 14 (March 1907).

"Exhibition of Pictures by Clarence H. White in Pratt Institute, Brooklyn." *American Amateur Photographer*, 16 (March 1904), 137–38.

Hartmann, Sadakichi, "Clarence F. [*sic*] White." *The Photographic Times*, 32 (January 1900), 18–23.

Hatton, Mann, "Famous Old Oils May Be Sent to Cellar to Make Room for Camera Masterpieces. Dean of Photographers [Clarence H. White] Sees Dawning of Day When Photography Will Take Its Place in New Field of Science and Art. Camera Constantly Revealing New Truths." *New York Public Ledger*, 5 (December 1913).

———, "Sought, Seen, Heard. Clarence White Contends that the New Photography Is Creating a New Field Combining Science and Art." *New York Evening Post*, 6 (December 1924).

"In Memoriam—Clarence H. White." *Photo-Miniature*, 17 (October 1925), 269.

Keiley, Joseph T., "Clarence H. White." *Photography,* 815 (June 25, 1904), 561—66.

————, "Exhibition of the Pictures of Clarence H. White." *Camera Notes,* 3 (January 1900), 123–24.

Kramer, Hilton, "Photography: American Classics." *The New York Times* (July 22, 1977).

Kühn, Heinrich, "Clarence H. White." *Photographische Rundschau,* 62 (1925), 388–99.

"A Letter from Clarence White." *Abel's Photographic Weekly* (September 22, 1923).

Lonsinger, Nancy, "He Dared to Be Different." *The Columbus Dispatch Magazine* (Ohio) (May 14, 1972).

Marks, Robert W., "Peaceful Warrior." *Coronet,* 4 October 1938), 161–71.

————, "The Photography of Clarence H. White." *Gentry,* 9 (Winter 1953–54), 134–39.

Outerbridge, Paul, "Patternists and Light Butchers." *American Photography* (August 1952), 52–56.

"Photographs by Clarence H. White." *The International Studio,* 40 (June 1910), 102–04.

"Review of the Exhibition of Clarence H. White at the Little Galleries." *American Amateur Photographer,* 18 (March 1906), 100.

Spencer, Ema, "The Newark Camera Club." *Brush and Pencil,* 3 (November 1898), 93–99.

————, "The White School." *Camera Craft,* 3 (July 1901), 85–103.

Stagg, Mildred, "Anton Bruehl." *Modern Photography* (September 1951), 26–32, 96–98.

Steichen, Edward J., "The Fighting Photo-Secession." *Vogue* (June 15, 1941), 22–25, 74.

Taft, Lorado, "Clarence H. White and the Newark [Ohio] Camera Club." *Brush and Pencil,* 3 (November 1898), 100–06.

Vestal, David, "Shows We've Seen: Clarence H. White—Photographs—The Museum of Modern Art." *Popular Photography,* 69 (November 1971), 195, 197.

White, Clarence H., "The Progress of Pictorial Photography." *Pictorial Photographers of America* (New York) (1918), 5–16.

White, Clarence H., Jr., and Peter C. Bunnell, "The Art of Clarence Hudson White." *The Ohio University Review,* 7 (1965), 40–65.